MICHAEL
KIDNER

Painting, drawing, sculpture 1959–84

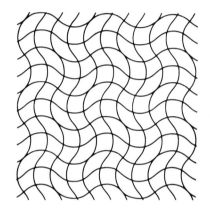

4 November – 2 December 1984

Serpentine Gallery
London

30 January – 2 March 1985

Hatton Gallery
Newcastle upon Tyne

Arts Council
OF GREAT BRITAIN

Contents

Acknowledgements

The work of Michael Kidner has been associated variously with the experiments in colour and optical resonance which characterised an important aspect of painting in the Sixties, with Systems art, and always with a vigorous search for order. We are delighted to present an account of his achievement which reveals both the variety of his art and the underlying consistency of his vision.

We would like to thank the artist and his wife, Marion, for their very considerable help with the preparation of this exhibition. Ronald Alley, Tim MacMillan and Shirley Gray have all given valued assistance to aspects of the show. We would also like to express our appreciation for the advice of Bryan Robertson, Stephen Bann, Francis Pratt and Peter Brades, all of whom contributed to the catalogue, and to Gordon House who designed it. Our further thanks are due to the many galleries who have kindly made works available for the exhibition.

Joanna Drew
Director of Art

Photographs by David Cripps, Hugh Gordon, Robert Aberman, Robert Malcolm Prudence Cuming Associates Ltd and lenders
Exhibition organised by Alister Warman
Assisted by Peggy Armstrong
Catalogue designed by Gordon House
Printed in England by The Hillingdon Press

ISBN No 0 7287 0433 1

A list of Arts Council publications, including all exhibition catalogues in print can be obtained from the Publications Officer, Arts Council of Great Britain, 105 Piccadilly, London W1V 0AU.

Foreword
by Bryan Robertson

Like all good artists, Michael Kidner writes with unpretentious clarity about his origins and intentions. 'It was not until I had turned thirty that I thought at all seriously of trying to make painting a career. Something in a Midland Industrialist background produced in me a sneaking suspicion that the painter was engaged in an occupation which was both self-indulgent and socially useless. It took several years to lay this bogey. In the early 1950s I went to Paris and started a long process of self education'.

He goes on in this statement, written in 1967, to describe how he studied at the atelier of André Lhote, moved on in the mid-fifties to the precepts of the St. Ives landscape abstractionists and absorbed the impact of American art in London a year or two later. American art confirmed at least one principle learned in Paris, that truly modern art involved the 'flattening of deep perspectival space such as the Renaissance painters had perfected'.

The idea of pure colour came next, stimulated by Kidner's discovery of the fact that 'the brightest image is produced by an after-image on the retina of the eye'. Kidner worked incisively in the field of pure colour, but after projecting pure colour through a minimal form of conveyance – identical bands of contrasting colour, to build up a 'sensation of colour areas rather than a sharply defined image', he has become increasingly absorbed by structure. He wants to make the spectator aware of 'the relation between the picture and its structure. If you like, the pictorial structure which makes the image is also the content of the painting.'

What comes through to me from these and other statements made by the artist is a puritan impulse or edge to creative reasoning and an urge to explore essences.

Kidner is engrossed by the ways in which structure may be made to perform, extend itself or yield fresh facets through systematic formal analysis. But the work as a whole tells me that as an artist Kidner is making extraordinarily beautiful objects and paintings, drawings and three dimensional forms which have their own strong and radiant presence. What also comes through, I believe, is that Kidner's work continuously seeks out and celebrates what might be called the disruption of the plot, the distortion of the effective process, and the exception to the rule which at once proves the rule and stands it on its head. The result of all this exploration is a series of paintings and drawings and constructions in which imaginative vitality always enriches the basic premise, whilst the mechanism by which the transformation of the original insight is achieved becomes itself a thing of beauty as in the recent drawings, dating from 1976 on, derived from an elastic cloth.

The beauty of the work is self-evident. An exemplary text written by Stephen Bann in 1972 for the catalogue for the Arts Council's *Systems* exhibition places Kidner within a context of loose associations or links with other artists. My concern now is that for a number of reasons we have become increasingly intolerant of the work of this era – an almost automatic cut-out in critical sensibility seems to descend each decade now toward earlier pursuits in art. Figurative art is now the thing, some of it deservedly so, but much of the applause comes from sources which always saw abstract art as error and – like the more rigid supporters of post-modernism – cheer or condemn with a fervour that tends to treat the artist's work as a mere reflection of their own extraneous and often reactionary beliefs. Kidner's work has a timeless authority which makes its own space and light and an optimistic sense, always, of disclosure, of opening up and extending the possibilities of visual intelligence and pleasure.

Michael Kidner
by Stephen Bann

As the once strident voice of the twentieth-century avant-garde dies down to a whisper, the rhetoric of revivalism is becoming pervasive and indeed almost inescapable. There is now a flourishing and prestigious Neo-Baroque, bravely attempting to recapture the times when personal and public mythologies could be blazoned across architectural spaces with a heady disregard for finish and finesse.

There is an invigorating if usually nostalgic Neo-Classicism, which summons up citations from the Western tradition and at the same time measures the gap between the original freshness and fullness of the classical vision, and the perilous act of retrieving it from our latter-day historical stance. While these movements occupy the centre of the stage, a profound shift in attitudes to the past is continuing to take place. This can be identified in particular with the special attention which both artists and art historians have begun to devote to the founding achievements of the Renaissance. For the avant-garde artist of the beginning of the century, the Renaissance represented the beginnings of bondage; the reign of perspective had confined visual expression to a straitjacket which was imposed without question by the institutions of academic art. For many of the artists, engaged in the end-game of late twentieth-century art, it is, by contrast, the speculative freedom of the Renaissance which strikes home so vividly. For these artists the rich systems of pagan and Christian iconography count for little beside the supreme emblematic achievement of the conquest of space.

It is in this context that the achievement of Michael Kidner seems to have a special resonance. In over twenty years of sustained and solid work, he has earned the right to direct our attention to aspects of the development of Western painting which underlie and determine the more flashy and superficial manifestations of contemporary fashion. Whereas the majority of contemporary painters, particularly those of the younger generation, have chosen to be *reactive* – registering their departure from modernism through visible signs of rupture and repudiation – Michael Kidner has remained, in every sense of the word, *constructive*. It has been his concern to relate the artistic representation of space to a declaration of values which is fundamentally in tune with contemporary thought about man and the universe. As he remarks: 'The order in a painting refers to a much larger concept of order outside the painting'. It may seem an innocent enough observation. But its implications have led him to change his painterly skin over the past two decades in what we can now see to have been a spectacular and courageous process of artistic metamorphosis.

The evidence for this change can be observed, first of all, in the paintings through which Michael Kidner made his reputation in the early 1960s. Their special qualities are accurately glossed by a statement which he made for an exhibition at the Grabowski Gallery in 1964: 'Optics present the challenge that was once offered by perspective'. In the work of this period, Kidner was effectively aligning himself with the powerful current in modern painting which had asserted the priority of colour over line – which had taken such varied models as Delacroix, Cézanne and Matisse as a pretext for flooding the canvas with an ever more open demonstration of the optical and expressive qualities of pure colour. More precisely, he was aligning himself with a counter-current within this current, which had incorporated the theoretical distance of Goethe and Chevreul, and the experimental attitudes of Itten and Albers, in a conscious attempt to control and delimit (as far as possible) the fascinating effects of colour interaction. At this stage, he was undoubtedly one of the most expert painters, in Britain or abroad, to lay claim to this idiom in which precise use of repeated elements created an optical 'dazzle' more intense than in any previous modernist work. Where the Abstract

Expressionists had insisted on gesture and process, but staked their chief claim on what Kidner called 'the direct assault on the unconscious', the Optical painters provided an experience that was both controlled and spontaneous. It was perfectly evident to the spectator that the painter had worked meticulously with series and repetition. Yet somehow his eyes told him a different story.

The metamorphosis to which I referred previously took place not as a result of any sudden theoretical shift, but as a direct practical outcome of these studies in colour. Experiment with the possibilities of the moiré effect in the mid-1960s led Kidner to the realisation that there were 'other possibilities' in the use of his characteristic wavy lines, and by 1974 he had so thoroughly assimilated the principles of repeated wave patterns that he could turn his attention to the representation of space. 'A grid is composed not only of lines', he asserted at this time, 'but of the spaces between the lines'. The remark may appear obvious, but it betokened a new awareness of what I have called the emblematic aspect of spatial representation. If the earlier work on colour definitely belonged within the Modernist bracket, continuing an experimental impetus which had developed particularly in the early years of the century, here was a return to line which paralleled though it did not imitate the scientific interest in perspective propagated by the Renaissance masters. The French art historian Pierre Francastel has written of the fascination of painters like Uccello with what he terms 'new objects': that is to say, the curving, complex geometrical forms which may take on the appearance of a jettisoned shield, or an elaborate headdress, but are really there to indicate the painter's expertise and delight in re-presenting in two dimensions the intricate regularities of a three-dimensional solid. Michael Kidner also works with 'new objects' – those artfully composed 'columns' which supply the exact information for his large and lively canvases. But he is not concerned (any more than the Renaissance painter) with mere ingenuity of transposition. When he talks of reducing 'the arbitrariness of description' he does not intend to convey that he is taking refuge in a facile purism. It is axiomatic, at any rate for this Post-Renaissance current of Western painting, that the exact method will achieve an effect of liberation: that by symbolic means man will recover, at least in the moment of vision, a knowledge of his world.

That this world is not the world of the Renaissance master is of course a tired commonplace. Michael Kidner's systems are not locked into order by the magnificent absolutism of a single-point perspective, which is itself a surrogate for the all-seeing eye of God. Like Paul Klee, who devised his delightful *Equals Infinity* (1932) in full knowledge of the modern transformations in mathematical and cosmological thought, Kidner seeks to find a plastic equivalent for his vision of a universe which eludes all representation in terms of fixity and permanence. The ideological wager which he has made and continues to support can be epitomised in simple terms: it is for infinity without transcendence.

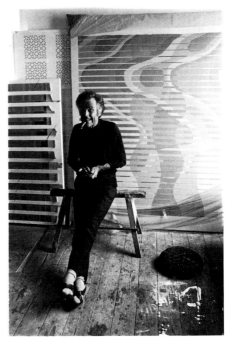

Michael Kidner in his studio 1972

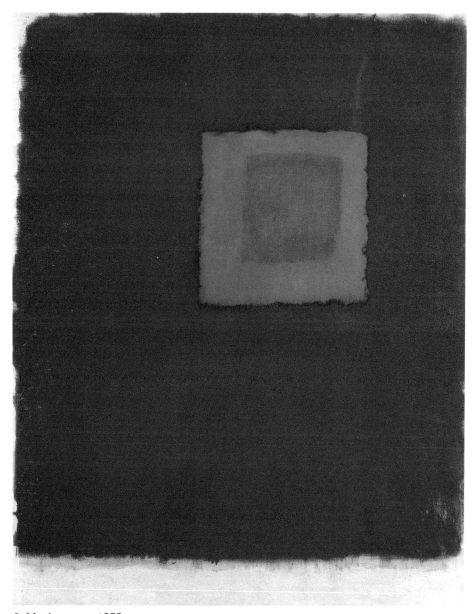

2 **Moving green** 1959

The texts accompanying illustrations when not already credited were said in conversations with Ronald Alley or Irving Sandler.

'Optics presents the challenge that was once offered by perspective'

See: Michael Kidner, Catalogue introduction, Grabowski Gallery May 1964

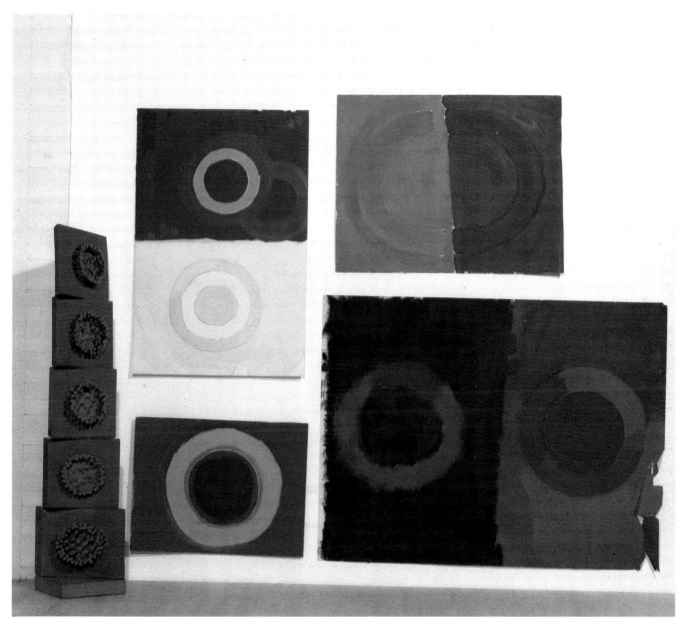

Studio installation 1959–60. Cat no.3 with four works on paper

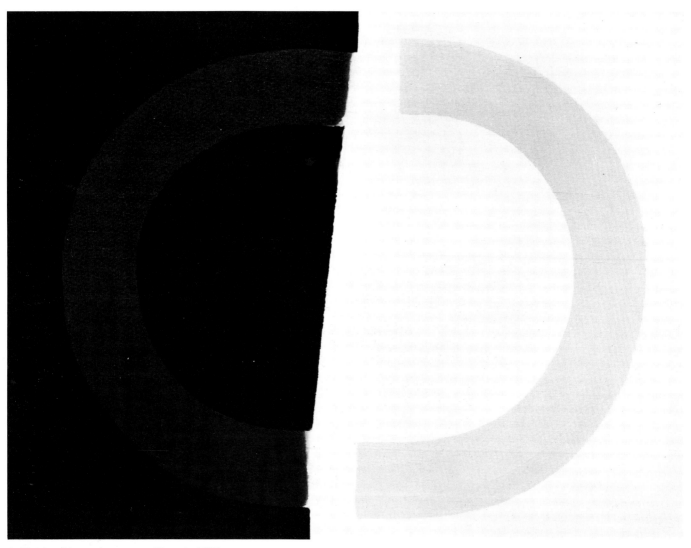

4 Black, white and orange split circle 1960

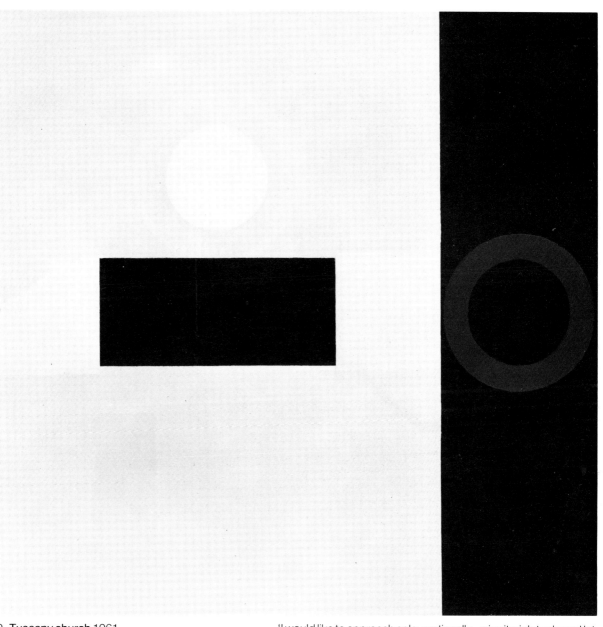

9 **Tuscany church** 1961

'I would like to approach colour rationally – give it a job to do and let the unconscious expression look after itself.'

Michael Kidner. Unpublished diary notes 1961

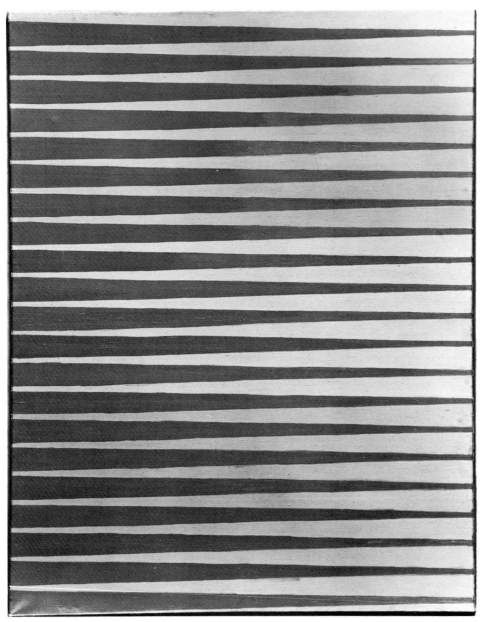

'A shape loses its identity if it is repeated often enough, and soon I began using nearly identical bands of contrasting colour in the belief that they would build up a sensation of colour areas rather than a sharply defined image.'

See: 'Kidner on Kidner', University of Sussex, 1967

14 Orange to violet 1961

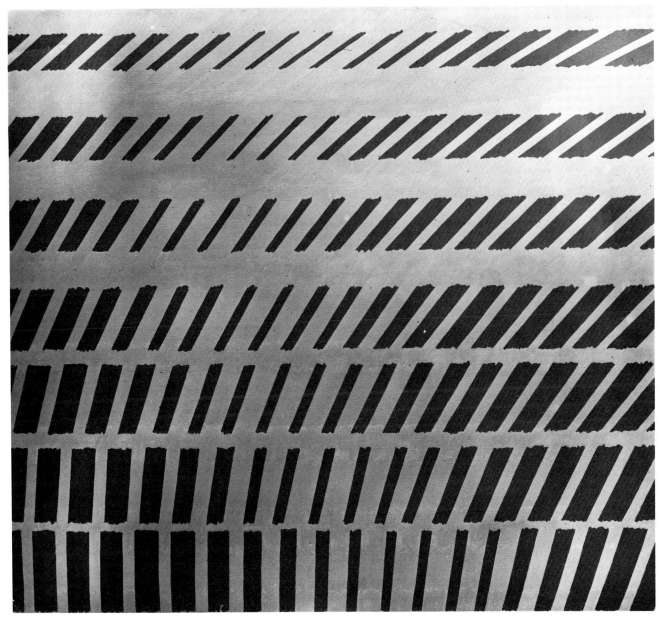

23 Ochre, blue and violet 1963

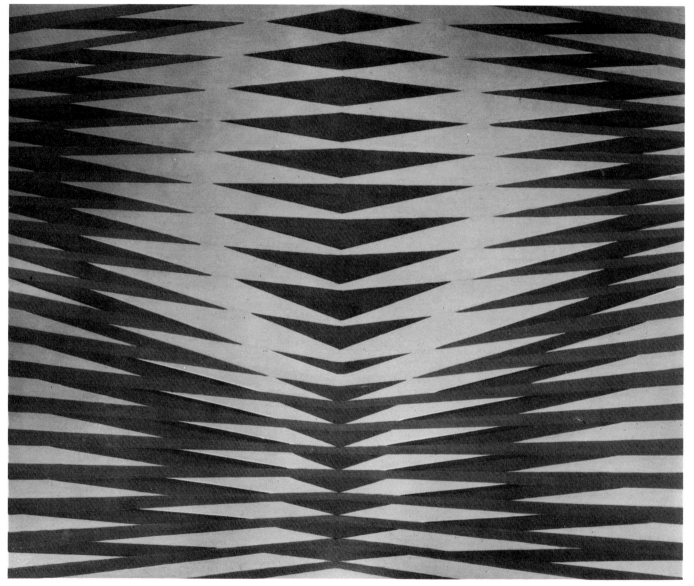

25 Orange, blue and green 1964

'I considered the stripe sufficiently anonymous to be used for two colour paintings. The interference pattern provided a solution to my search for the third colour. If you have two colour bands crossed by a third at a slight angle the effect it produces is an entirely new pattern.'

See Charles Ronald Coppin's Essay: Michael Kidner. Chapter One: Optical. M.A. in Art Education 1978/9

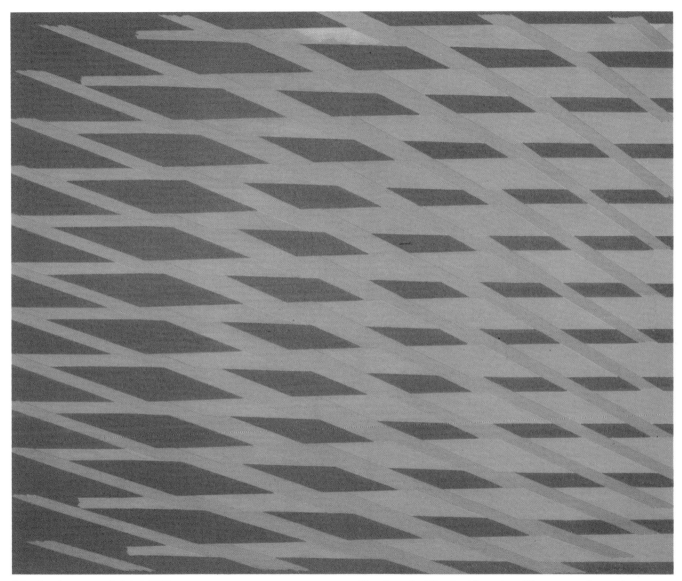

26 Blue, brown and violet 1963

'Bands end arbitrarily at the edge of the canvas. A wave has a measurable length from crest to crest which means that waves can be put in and out of phase in a manner that straight lines cannot.'

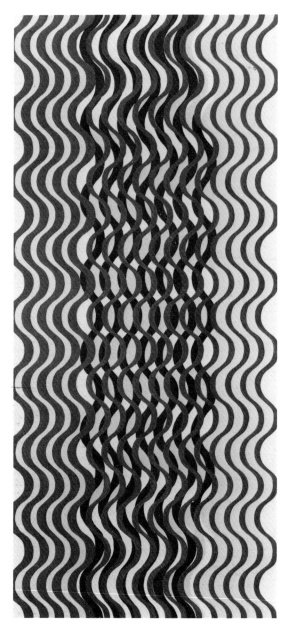

29 Yellow, blue, green and white wave 1964

Illustrated right
'In the use of the fourth colour I found that colours could be paired and the pairs could progress in and out of sequence across the canvas. But while the colours moved horizontally the waves moved vertically. I returned to this theme in 1973 in the wave lattices.'

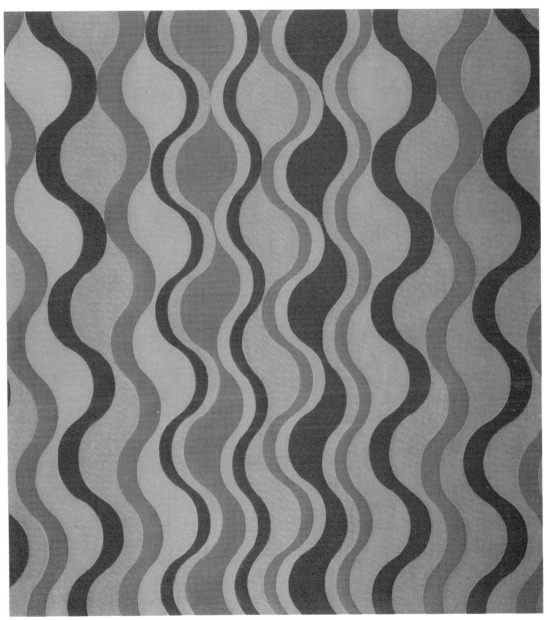

34 Orange, blue, pink and green 1965

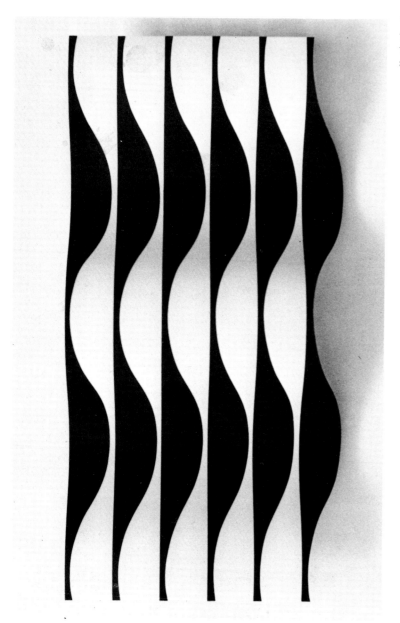

'The serial idea arose from the problem of relating a wave to the rectangle. I had the choice of making the framing edge of the canvas curvilinear and thus extending the internal structure of the picture to the edge. . .'

108 **Multiple (silkscreen on perspex)** 1965 Editioned 1970

'. . . Or of introducing the edge into the internal structure of the picture.'

41 Yellow, violet, light red and blue 1967

Systems and the work of Michael Kidner
by Francis Pratt, University of Stirling

Michael Kidner has written: 'we all feel awe in front of beauty, as much before an Islamic temple or a Gothic cathedral as before the Alps or a thunderstorm. Our first thought may be to kneel in wonder as feeling overwhelms us. Later we reflect. We ask questions inspired by experience. Art is produced out of both these states of mind' (Kidner, 1976). Any attempt to understand Kidner will fail if we allow either the rationality of his working method, or the orderliness in the appearance of his paintings, to obscure the importance of wonder and deep feeling in everything he has done. Kidner is a man who combines passionate feeling with insatiable curiosity. It is this combination that has driven him on in his search, not only for beauty, but also for self awareness and self definition, and that gives rise to the poetic and expressive dimensions that so often reveal themselves in his work.

Why was Kidner attracted to rationality and orderliness? Why was it that he came to adopt a 'systematic' approach to the generation of his compositions? Essentially there were two reasons. First, he saw systems as a basis for the coherent development of ideas. Coherence would be possible because systems would enable recoverability; recoverability being what would distinguish the systems approach from the propositional approach of the American Abstract Expressionists and from the rational approach of the Bauhaus. Second, he saw systems as a route to the discovery of the unknown.

Artists have always had to face the problem of how to create the unknown from the known. All thought and activity is heavily dependent on memory and habit. Consequently, there is a strong tendency for artists, like other mortals, to repeat themselves, whether this be in terms of ideas or mark-producing gestures. Even sensibility is necessarily largely determined by experience. If someone says that he *knows* what he likes, this means that what he likes is rooted in the past. It means that he is defended against new experience. It means that his taste is pre-determined. Yet this state of affairs is a matter of common experience. We all know what we like. We are all habit bound. We all respond to the present in terms of the past.

In these circumstances, how can anyone be creative? The answer would seem to be that creativity depends on interactions between person and environment. These may be accidental or they may be considered. They may be a consequence of a failure to control the environment, whether as a result of chance occurrence or ineptitude; they may be a consequence of the use of aids or procedures that transform our perception or determine what we can achieve.

The use of aids and procedures which force new ways of perceiving is universal amongst painters of all kinds. For example, the use of the flat picture surface itself forces a way of perceiving colour relations that is different from the way they are perceived in the three dimensional world (cf. Gilchrist, 1980, who showed that the same area of surface could be perceived as either black or white, depending on whether it was seen as co-planar with neighbouring areas of surface or not). Other examples abound of widely used artistic practices that force change in habits of looking and enable artists to see in new ways. The usefulness of these tools has its limits, for the same tool will tend to force the same 'new' way of looking every time it is used.

A similar picture can be drawn in relation to the tools that are used, not for helping us see our environment in new ways, but for helping us structure it creatively. For artists this means tools that aid pictorial composition. The rules of perspective are a good example of such a tool. Their use had a profound effect on pictorial composition during the Renaissance. At this time they clearly demonstrated their creative potential. However, this potential had limits. In time the

References
Gilchrist, A.L., 1980, 'When does perceived lightness depend on peceived spatial arrangement?' Perception and Psychophysics. Vol 28 (6) pages 527–528.

Kidner, M., 1976, English drawing and rational concepts. Catalogue to exhibition. Delft.

Kidner, M., 1983, Series. Catalogue to exhibition, Newport, Isle of Wight.

limits were reached. The rules of perspective can no longer generate exciting new compositions. They no longer have the power to surprise our expectations or extend our awareness.

It was the search for new rules capable of breaking the tyranny of habit, particularly those habits of mind that determine personal taste, that led to the use of the systems approach to painting. The idea was straightforward. Simple pictorial elements could be manipulated by means of rational procedures (often involving numerical manipulations) to yield complex, yet comprehensible compositions. The compositions would be comprehensible to the viewer because their organizing principle would be evident. Thus, knowledge of the system would provide the key to making sense of the composition.

An implication of both the systems method and the systems rationale was that the parts which were to be subjected to systematic analysis would have to be definable. A consequence of this was that any stage through which the painting went would be 'recoverable'. This was an extremely attractive feature. It meant that paintings were no longer one-off shots in the dark, in which each decision irrevocably effaced its history and closed options to the artist. At any stage in a systems painting any number of options could be tried since that stage could always be recovered in a separate painting or study. In this way the element of recoverability offered hopes that systems could be developed organically. There was no need to go back to square one at the start of each painting. Good ideas could be developed and investigated systematically. Mistakes could be learnt from.

Thus, Kidner had three reasons for his original attraction to the use of systems. He saw them as a tool for breaking the tyranny of personal taste, as a means of making his compositions more comprehensible and as a method of facilitating reproducibility. Later, he came to see other advantages. In particular, he came to appreciate the implications of the fact that the process of unravelling systems gave systems paintings a temporal dimension. Also, he realized that systems could be regarded as fulfilling a function analogous to that performed by objects in representational paintings.

They could be used as a means of drawing the spectator into the world of the painting, as a preliminary to enjoying the fruits of that world, and they could provide an experiential context which could creatively constrain the viewer's experience of the painting.

Kidner's expanded awareness of the potential of systems reflects his growing interest in the relation between the spectator and the painting. Progressively this interest had come to influence his thought. His attitude had something in common with the attitude of those Renaissance painters who saw perspective as a tool for controlling the spectator. Their idea was that people would tend to view paintings from the viewpoint implied by the perspective constructions. Thus, if they wanted to encourage a contemplative frame of mind in spectators of a devotional painting, they could imply a distant viewpoint. If, on the other hand, they wanted to give spectators a sense of personal participation, they could imply a near viewpoint and draw them into the midst of what was happening in the fantasy world of the picture. In this way the perspective 'system' could be used for religious or philosophical purposes.

Kidner very much wanted to encourage the participation of spectators in his paintings and his reasons for this could very properly be termed philosophical. However, he did not want the spectators to become involved in the figurative content of the picture. He wanted them to experience the painting as being incorporated into what he refers to as, 'their own psychological space' (Kidner, 1983). This is why he came to place such an emphasis on the role of time and, consequently, on the role of memory. He realized that wherever the subject of a painting is a superordinate construction that requires being put together over time, that subject is inaccessible without the creative participation of the viewer. Subject and imagination cannot be separated. But, and this is of crucial importance to Kidner, their synthesis is not achieved by an escape into the fantasy of the picture world, but by an acceptance of the centrality of the 'self' in human experience. People should not conceive of themselves as looking out at an external world, but should also recognize the fact of the world's incorporation into themselves.

Pratt, F.R., in press, A perspective of traditional artistic practices. In, Freeman, N.H. and Cox, M. (Eds) 'The creation of visual order'. Cambridge University Press.

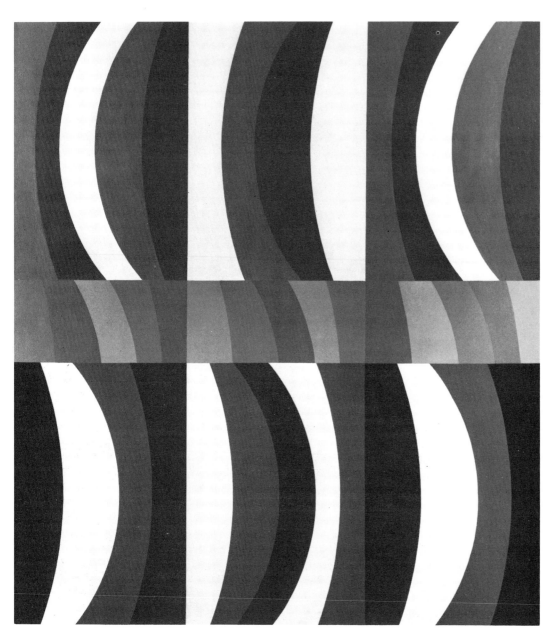

46 Three primaries 1967

'The serial idea arose because I wanted to distinguish shape from colour. To this end I used three colours and four shapes. No shape can be identified by a particular colour. The colour yellow, for example covers all possible shapes.'

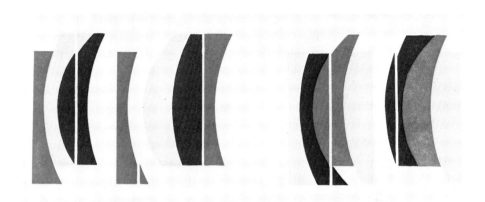

111 Sussex 67 1967

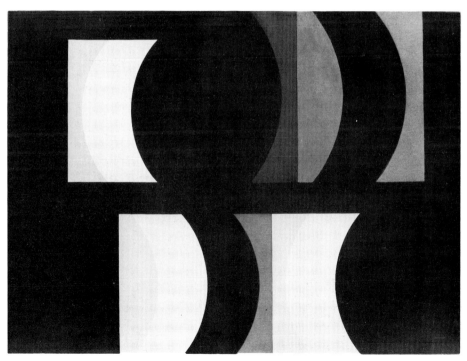

48 Washington DC no.1 (green) 1968

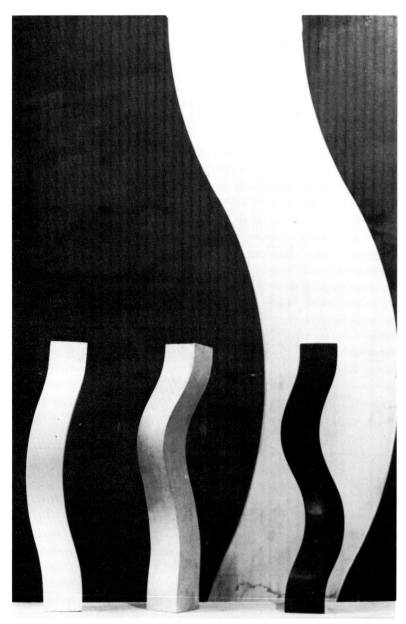

'When I started to make a column in the summer of '69 I had in mind a solid block of colour. Very soon however the shape became more interesting to me than the colour.'

Studio installation 1970

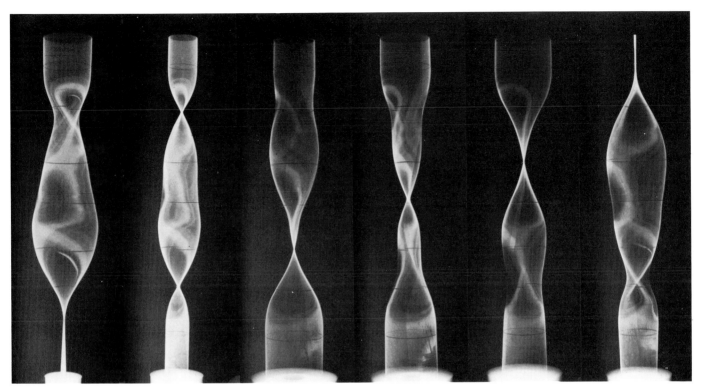

51 Six views of spinning wire column 1970

'The column had two profiles, the first contained a single curve and the second a curve and a half. My interest in making the column lay in the fact that it brought two wave surfaces into relation with each other and I found it difficult to imagine how one view would change to the other in real space.'

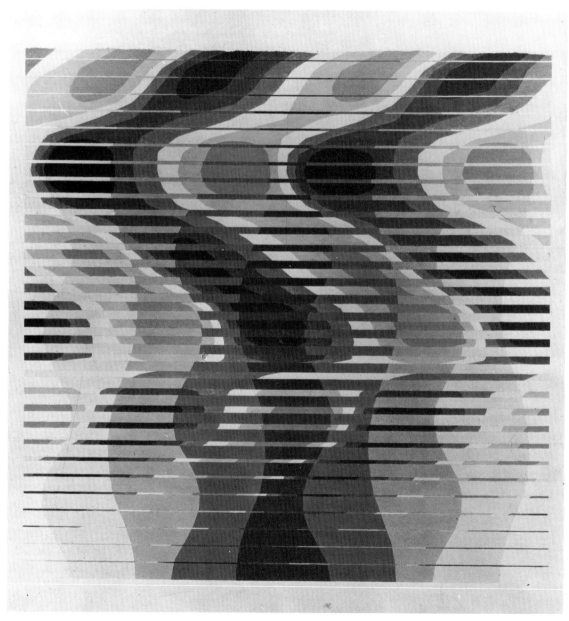

57 Colour column no.4 1972

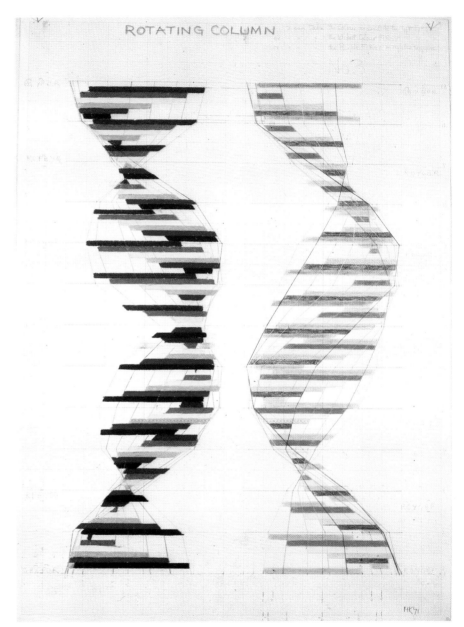

54 Column drawing 1971

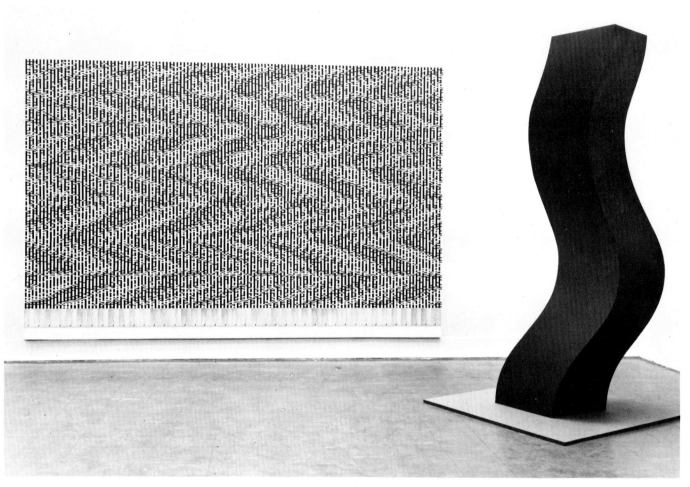

58 Column no.2 in front of its own image 1970

'The concept of Heaven is perfect because you can never enter it in this life. It is a two dimensional order and therefore a painter's paradise. But when you try to occupy your imaginary order you meet with some surprises. It is the area between the second and third dimension which interests me – the order that lies between imagination and reality.
Reality involves experience.'

See: catalogue statement, Systems Exhibition 1972–73
Michael Kidner

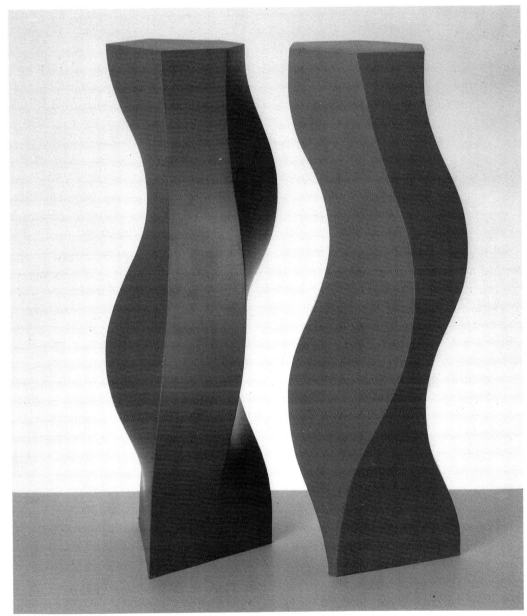

59 Double hexagon column 1973–81

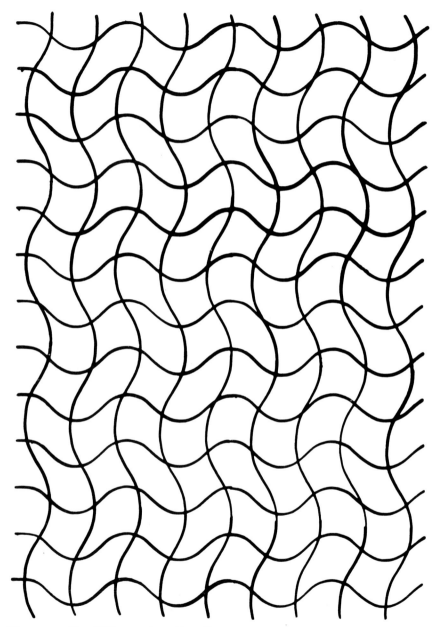

'I find that a grid composed of wavy lines pertains to the infinite quality of an Ad Reinhardt painting. The endless number of linear intersections both offer and resist any sort of visual resolution.'

See: catalogue statement: Michael Kidner Systems 2 Exhibition 1973

'I had been thinking of the wave as a simple line or band. In these drawings I explored it in the context of a grid. A grid is composed not only of lines but of spaces between the lines and it is the spaces which become the structural elements.'

See: Michael Kidner, catalogue introduction Lucy Milton Gallery, April (1973)

Lattice proposition 1973 reproduced from Systems II catalogue

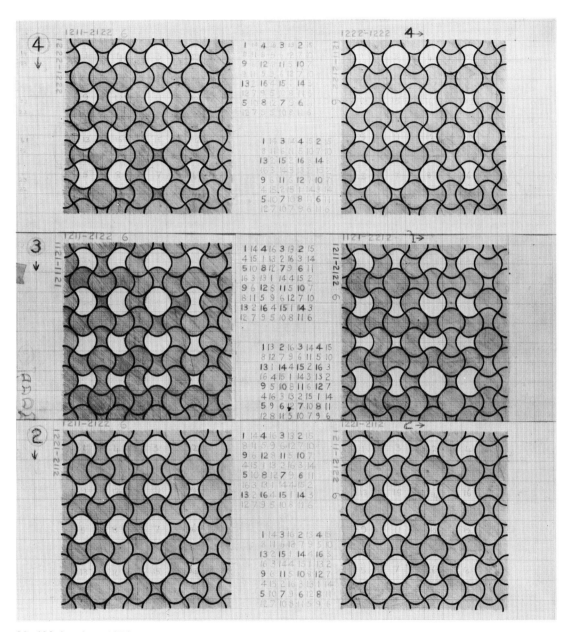

60 **432 drawings** 1973

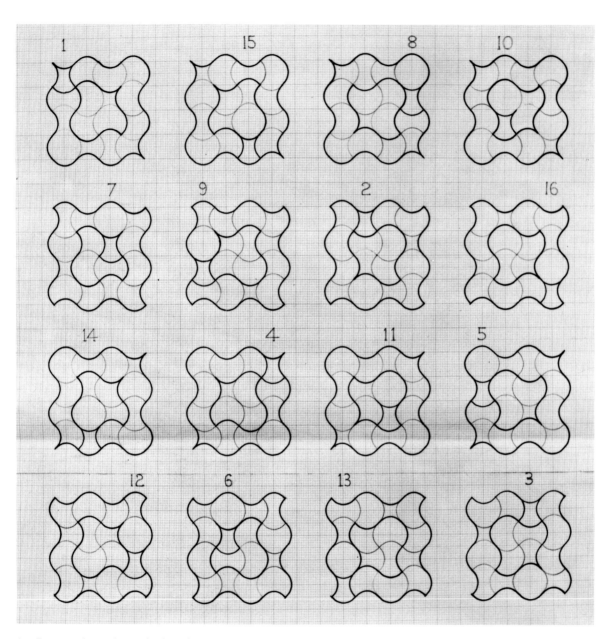

61 Permutations of wave lattice 1975

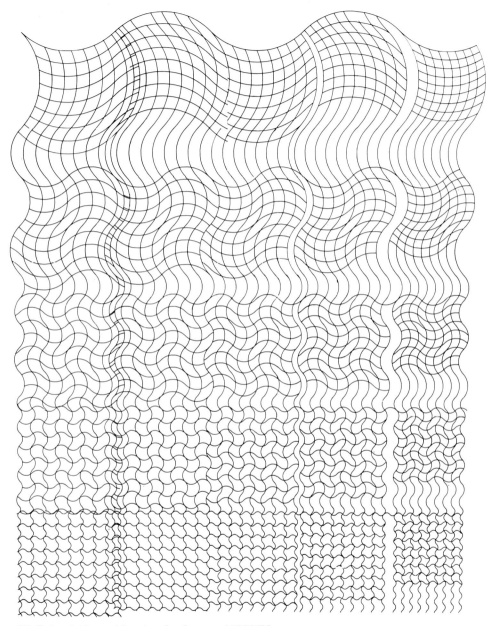

66 Extendable working drawing for mural 1982/83

A B

A B

68 Transformation of wave lattice 1973

73 **Canterbury** 1976

Stretched waves 1976
(published in 'working information')

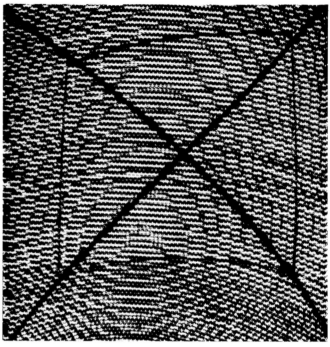

Warped square 1976
(published in 'working information')

'I wanted to fit several rows containing the same number of waves between two converging lines and the woven elastic cloth offered a solution.'

'I stretched a square of elastic cloth, drew a square on it, ruled a series of parallel lines across the warp in the cloth and then released the tension. I hoped in this way to show the forces operating on the figure to cause the distortion.'

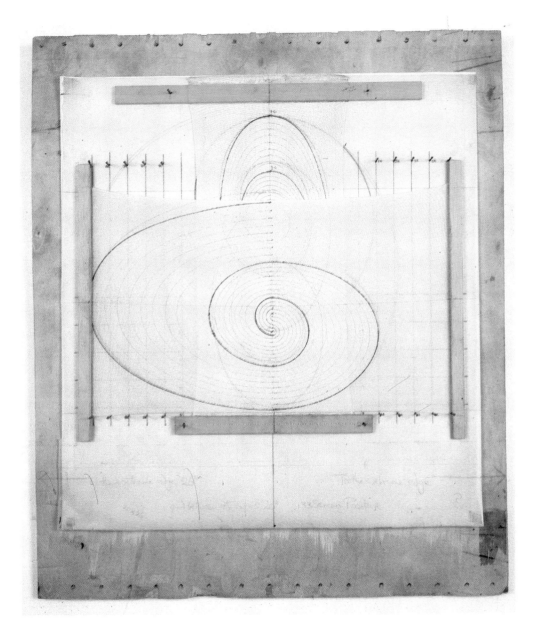

76 **Looped circle** 1978

'In the elastic drawings the pure circle, the pure square is the reference – something to do with the conflict between what should be and what is: between the concept and the experience.'

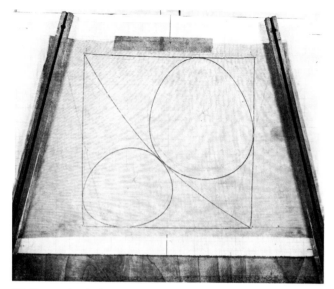

95 Square in circle 1 1976

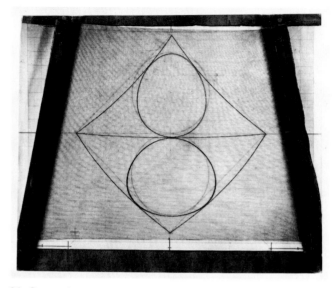

96 Square in circle 2 1976

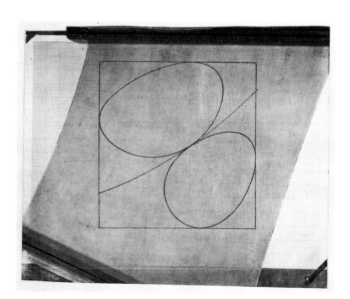

97 Square in circle 3 1976

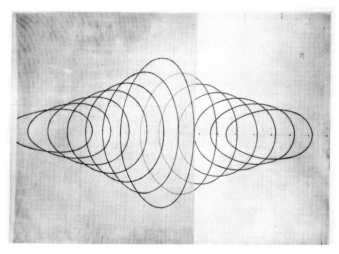

98 Concentric circles 1979

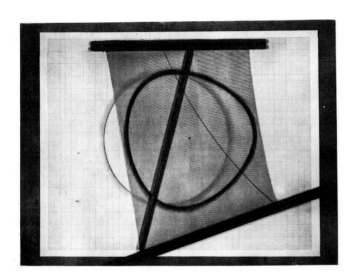

100 **Circle 1** 1979

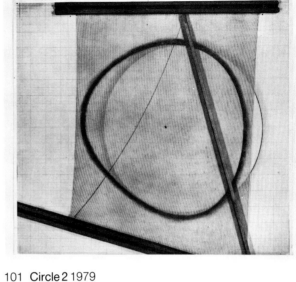

101 **Circle 2** 1979

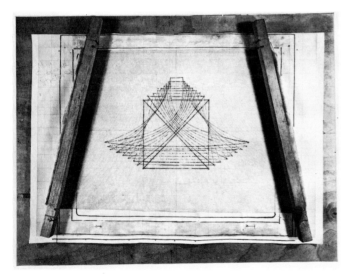

109 **Nine stretches AP** 1977

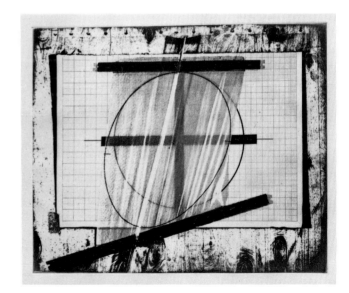

110 **Cross stretch (line) AP** 1977

39

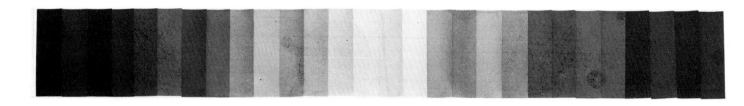

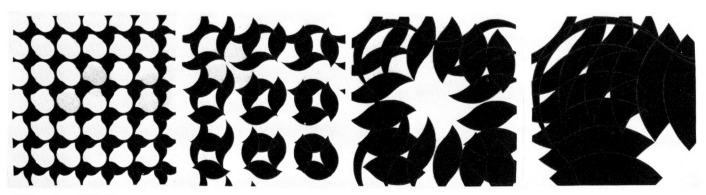

86 **Requiem** 1982/83

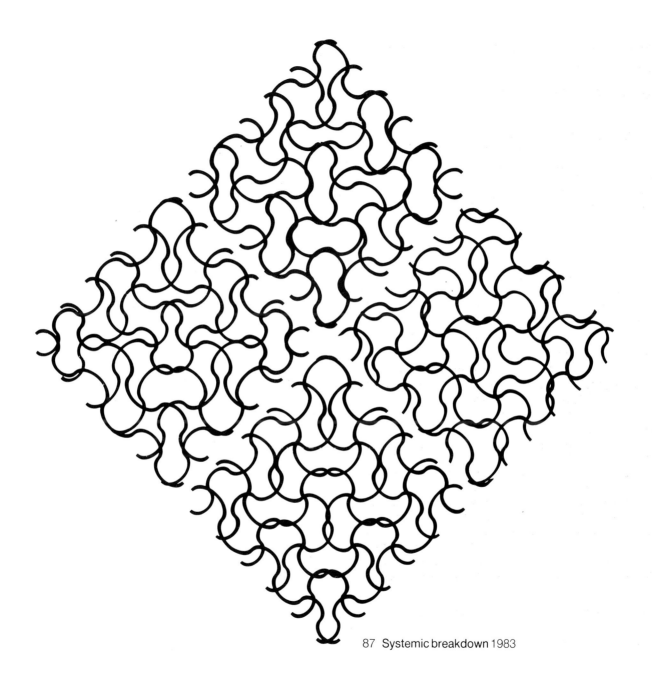

87 Systemic breakdown 1983

Column, square and grid: three works considered
by Peter Brades

Colour column No.2 1971

This large painting is a visualized description of the doubly-curved, glass-fibre column placed in front of it. The painting is twice the height of the column, repeating the column above itself. In fact, it is slightly over twice the height, for the top few inches start the pattern again, to emphasise the repetition. The doubling is intended in any case to express the pattern more comprehensively.

The painting shows the faces and, more importantly, the curves between the faces as the column is rotated clockwise. Three of the four faces are shown, with the vertical stripes recording six turns of 15° from face to face, reading the canvas from left to right. The colours are coded from the spectrum, with red representing the curve on the edge nearest the spectator and blue the farthest, the valleys.

What Kidner is doing is measuring the column with colour and showing that measurement can have effect by revealing a statistical pattern. Placing the actual column in front of the painting gives immediate space and depth before the spectator. One beholds an 'edifice', a complete argument, a complete statement. The size of the painting is important. It is sufficiently 'life-size' for the spectator to have a direct physical comparison with it. It has a 'torso', where the mass of the painting stands above the white base; its elements, the painted vertical bands and rectangles, are similar in size to human features. The result is that, with the depth created by the column and the very human scale of the painting, an environment has been achieved in which we can participate. We can judge, not just by eye but bodily, a commensurability between ourselves and the geometrical statement expressed by the form of the column in both its states, the three- and the two-dimensional.

As well as the photographic associations present, its likeness to the recording process of the camera, there are architectural and sculptural ones. The column itself has the attraction of a figure, especially one high up on a building, where personal details do not count. The column contains the great, emotive S-curve of sculpture, of madonnas and dancing *shivas* and crucified Christs. The formal appeal of the curve is very deep. It touches an aesthetic chord; it indicates the counterpoint between the intellectual and sensual responses that art relies on for effect. The column has an awesome history but this examination of it is an original one.

In architecture, too, the column has a similar figurative potential, but it can also express movement and time. Walking around a column is in some ways like walking along a wall. The tension between the individual and the surface, heightened often in a loggia or colonnade, is one of the great experiences in building. Here it is contained in a canvas as a record of motion. *Colour Column No.2*, in giving visual form to the idea of measurement, takes additional significance from such connections.

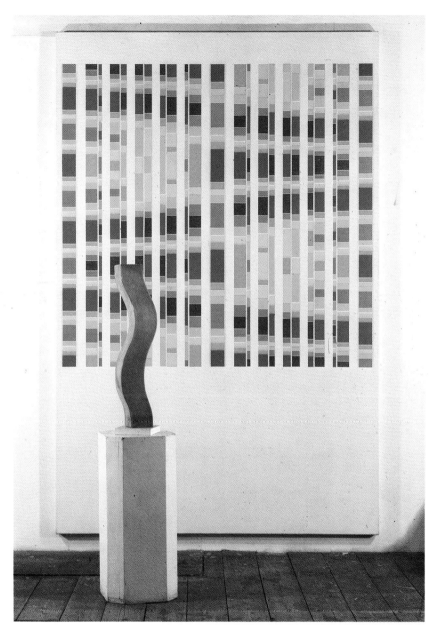

55 Column in front of its own image II 1971

Extended square 1978–82

The 'scientific' joy of Kidner's art is nowhere more clearly shown than in the series of 'stretch' pieces he has made since 1976. Very beautiful images have resulted from his inquisitiveness. Starting with woven elastic cloth and a movable frame, simple geometric figures are progressively stretched and distorted. Often what emerges is a complete inversion of the original. Stretching across a plane suggests layers and therefore depth and hence something tangible and measurable. The notion of expansion and contraction, here so nicely developed, recalls the Doppler effect in noise or light, where a notion of measurement again comes sharply to life because it has a human, physical dimension. The actuality, the presence of the stretch pieces has great charm and approachability. It is a significant strength of Kidner's work that it balances the world of thought with the world of action; the detached world of science and mathematics with his own experience.

Extended square is generated from a square divided equally nine times in both directions. Semi-transparent elastic cloth is placed over it and the square traced through. Then the sliding frame is moved by a certain amount and the square traced through again. Each trace onto the elastic is copied onto a separate sheet of tracing paper which is slid under the cloth to be traced the next time, as a regular development of the original square. The final composite records the whole sequence in what has become a kind of self-commentary by the square, supervised by the artist. He has been the instigator, not the dictator, promoting the revaluation of an unexpected resource in a basic everyday shape.

In the next two parts of *Extended square* alternate bars are extracted from the original square, five out of nine, and set against their stretched opposites. They appear to weave together, to interpenetrate, and this appearance becomes actual in the right-hand relief, where the construction has real depth. The contrast between the bars and the curves represents the essence of the change wrought through the stretching. The contrast is enhanced by the material contrast between the perspex relief and the central drawing, where the image has been built up first in layers of grey paint to resemble tracing paper and then silk-screen printed.

The materials and the materiality, the constructed quality of the whole piece make it richly satisfying. It sums up many of Kidner's concerns, ranging from the study of measurement and particularly the continuous flow between points that underlie some of the most influential scientific ideas of our time, to the contradictions and uncertainty of everyday. They are felt and even epitomized in the changing fabric of the work.

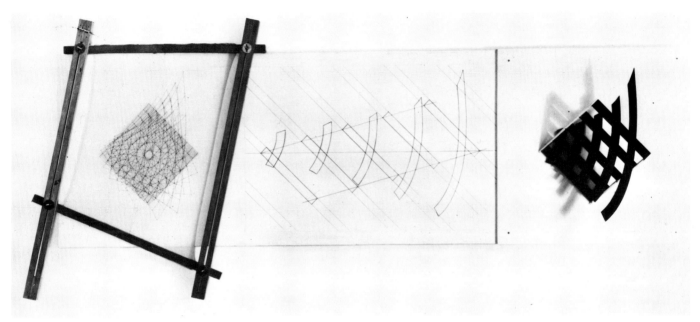

78 **Extended square** 1978–82

Formation and transformation (Nine panels) 1982

A wavelength, unlike a straight line, contains its own measure. Kidner's investigation of measure becomes more precise with the numerous wavy grid drawings done through the seventies and early eighties. Many are wonderfully difficult to imagine but this is perhaps not surprising if we consider how dependent we are today on visual aids like radar for our survival. The artist's sensibility nudges the spectator towards a visual grasp of a world moving beyond the range of immediate sensation. The key to understanding the grids is to find the compositional system that develops. Kidner has in mind a comparison with the predictive methods of astronomers in looking for new stars, using their knowledge of existing ones. Pattern is used as an aid to looking beyond the horizon.

To read the pattern in *Nine Panels*, one first has to locate the basic unit, what the artist thinks of as a condition of unity, a state of rest almost, or of potential. In this case, the starting point is the middle left-hand panel where the grid, though wavy, is completely regular. The pattern develops in two directions from this base. If we look down and along the bottom row from left to right, the wave is constant but the grid shrinks. If we then return to base and look along the middle row, left to right, and up to the top row, right to left, we see that the grid now remains constant but the wavelength is doubled each time. The same diagonal symmetry occurs but the grid spaces double in size. The shape in the top left-hand section of the base unit, for example, is found repeated but enlarged in the panel next to it and so on. As the squares develop we get drawn further and further into the grid, and feel a sense of time as a new element, additional to the growing power of the pattern. How soon before we can step in? This is not a demonstration of a geometric notion, it is something more alive and physical.

As in the earlier colour field paintings where the space was defined by subtle composition so there are valid artistic reasons why this grid drawing has the quality it does, and why we find it interesting.

One of the most dynamic features in modern art has been contour; contour separated almost from what it surrounds. In the grid drawings we have a version of the contour. With the large grid the line takes on a graphic power of its own, creating an occupiable space. With the small grids the spaces matter more. Like mosaic tiles or tesserae they have an overallness that suggests a volume, something to move in. The pattern, coming from the changing relationships of contours as the waves slip across the page, is visually as stimulating and complex as many an Islamic tiling pattern. One longs to see a floor or wall executed from these grids. Kidner has been quite specific about his aims in this context. He has written 'I want a pattern which I can occupy, as much as Renaissance painters made space in their paintings which they could occupy. My relationship with the environment is different from that of the Renaissance. I feel an effective part of a secular world and no longer a passive spectator. I have to find my place in a world viewed as an Ecology'. Such a world-view accepts mathematics and rational explanation in preference to mystery. It will not accept the word of God; it wants, in its democracy, everyone to participate and understand.

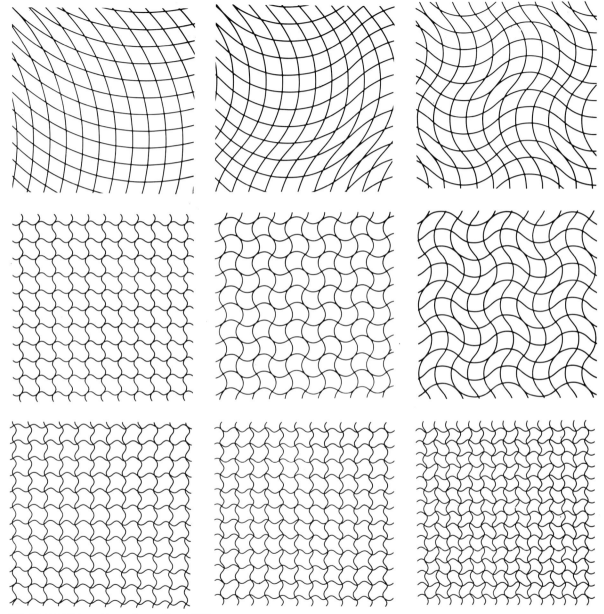

85 Formation and transformation 1982

Catalogue

Dimensions are given in inches and centimetres in this order: height, width or greatest diameter and, where relevant, length, depth or thickness.

The works are in the artist's collection unless otherwise stated.

Painting, drawing, sculpture 1959–84

1
Raindrops 1957/58
Oil on canvas
18×14in/45.7×35.4cm
Private Collection

2 *Illustrated in colour page 8*
Moving green 1959
Oil on canvas
36×29in/91×74cm
Private Collection

3 *Illustrated in colour page 9*
After image sculpture floating orange 1960
Nails, paint and wood
20×3¾×4½in/51×9.5×11.5cm

4 *Illustrated page 10*
Black, white and orange split circle 1960
Oil on canvas
27×36in/69×91cm

5
Orange, blue red/white split circle 1960
Oil on canvas
49×60in/124×152cm

6
Rising sun 1960
Oil on canvas
60×40in/152×102cm

7
Circle after image 1960
Oil on canvas
60×40in/152×102cm

8
Circle after image 1961
Oil on canvas
60×40in/152×102cm

9 *Illustrated page 11*
Tuscany church 1961
Oil on canvas
60×60in/152×152cm

10
Mars violet, orange and white 1961
Oil on canvas
32×48in/81×122cm
Arts Council of Great Britain

11
Red object 1961
Perspex and wood
17¼×19½×2½in/44×49×6.5cm

12
Black parallelograms 1961
Perspex
25×6¼×6¼in/63.5×16×16cm

13
Orange, green and violet 1961
Oil on canvas
64×86in/162.5×213.5cm

14 *Illustrated page 12*
Orange to violet 1961
Oil on canvas
50×41in/126×104cm

15
Orange and violet 1961
Oil on canvas
50×41in/127×104cm
Trustees of the Tate Gallery

16
Yellow and grey 1962
Oil on canvas
48×40in/122×101cm
Kirklees Metropolitan Council/Huddersfield Art Gallery

17
Aluminium, white and concealed yellow relief 1962
Aluminium foil, paint on wood
48×74in/112×188cm

18
Aluminium, grey and white relief 1962
Aluminium foil, paint on wood.
20½×38in/66×97cm

19
Aluminium, yellow and white relief 1962
Aluminium foil paint on wood
24×32in/61×81cm

20
Big pink 1962
Aluminium foil, paint on wood
61×57in/155×145cm

21
Yellow grey relief 1963
Paint on wood
39×55in/99×140cm

22
Blue, green and grey 1963
Oil on canvas
66×72in/168×183cm

23 *Illustrated page 13*
Ochre, blue and violet 1963
Oil on canvas
66×60in/168×152cm
Merseyside County Council: Walker Art
Gallery, Liverpool

24
Red, green and blue 1963
Oil on canvas
43×60in/109×152cm

25 *Illustrated page 14*
Orange, blue and green 1964
Oil on canvas
49×60in/124.5×152cm
Gulbenkian Foundation, Lisbon

26 *Illustrated in colour page 15*
Blue, brown and violet 1963
Oil on canvas
49×60in/124×152cm
Gulbenkian Foundation, Lisbon

27
Rotational II 1964
Oil on canvas
43×44in/109×112cm

28
Rotational III 1964
Oil on canvas
60×60in/152×152cm

29 *Illustrated page 16*
Yellow, blue, green and white wave 1964
Oil on canvas
48×22in/122×56cm

30
Blue, green and white wave 1964
Oil on canvas
88×52in/224×132cm

31
Brown, blue and violet 1964
Oil on canvas
50×40in/126×101cm
Southampton Art Gallery

32
Red, yellow and blue 1965
Oil on canvas
40×60in/101×152cm
City of Manchester Art Galleries

33
Red, yellow and blue wave 1965
Oil on canvas
86×58in/218×147cm

34 *Illustrated in colour page 17*
Orange, blue, pink and green 1965
72×66in/183×166cm
Merseyside County Council: Walker Art
Gallery, Liverpool

35
Mauve, brown, green and ochre 1965
Oil on canvas
40×60in/102×152cm

36
Mauve, brown, green and ochre 1965
Oil on canvas
72×66in/183×168cm

37
Butterfly wings 1966
Oil on canvas
66×72in/168×183cm

38
Red China 1966
Oil on canvas
219×158cm
86×58in/218×147cm

39
Red, green, yellow and grey 1966
Oil on canvas
66×72in/168×183cm

40
Blue, green, violet and brown relief 1966
Acrylic on canvas
56×73in/142×185cm
Peter Stuyvesant Foundation

41 *Illustrated page 19*
Yellow, violet, light red and blue 1967
Oil on canvas
70×64in/178×163cm
Arts Council of Great Britain

42
Black, white and grey 1967
Oil on canvas
36×29in/91×74cm

43
White divide 1967
Oil on canvas
44×48in/112×122cm

44
Colour and tone wave 1967
Oil on canvas
36×30in/91×76cm
Drs. J.M. and M. Morris

45 *Illustrated page 22*
Three primaries 1967
Oil on canvas
72×66in/183×168cm

46
Three primaries 1967
2nd version with white
72×66in/183×168cm

47
Trichromatic five piece 1967
Gloss paint on wood
5 parts
84×72in/213×183cm

48 *Illustrated page 23*
Washington DC no 1 (green) 1968
Acrylic on canvas
48×66in/122×168cm

49
Washington no 3 (yellow)1968
Acrylic on canvas
72×108in/183×274cm

50
Wire column 1970
Wire
32×2½×2½in/81×6.5×6.5cm

51 *Illustrated page 25*
Six views of spinning wire column 1970
Photograph
8×35in/20×89cm

52
Column no. 1 in front of its own image 1970
Acrylic on canvas
44×44in/112×112cm

53a/b
Shaped column painting I 1970
Acrylic on canvas on board
32×29in/81×74cm

54 *Illustrated in colour page 27*
Column drawing 1971
Crayon on graph paper
30×22in/76×56cm

55 *Illustrated in colour page 43*
Column in front of its own image II 1971
Acrylic on cotton duck
Green fibreglass column
90×60in/228×152.5cm

56
Colour column no 3 1971
Acrylic on cotton duck
48×72in/122×183cm

57 *Illustrated page 26*
Colour column no 4 1972
Acrylic on cotton duck
82×78in/208×186cm

58 *Illustrated page 28*
Column no 2 in front of its own image 1970
Acrylic on canvas with photographs
84×126in/213×320cm

59 *Illustrated page 29*
Double hexagonal column 1973–81
Fibreglass
27½×7½×8¾in/70×19×22cm

60 *Illustrated page 31*
432 drawings 1973
Ink and pencil on graph paper (detail)
76×90in/193×274cm

61 *Illustrated page 32*
Permutations of wave lattice 1975
Ink on graph paper
25½×25½in/65×65cm

62
Heart landscape no.1 1974
Acrylic on canvas
39×55in/99×140cm

63
Heart landscape no.2 1974
39×55in/100×140cm

64
Infinite grid series 1–6 1975
Ink on paper
22×30in/56×76cm

65
Two computer drawings 1975
Printouts
17×16½in/43×42cm each

66 *illustrated page 33*
Extendable working drawing for mural
1982/1983
Ink on paper dry mounted on linen
93 × 87in/236 × 221cm

67
Wave recording with process 1973
Acrylic on cotton duck
86×48in/218×122cm

68 *Illustrated page 34*
Transformation of wave lattice 1973
Ink on paper
21×29in/53×73.5cm

69
Analysis of a wave pattern 1973
Acrylic on cotton duck
36×36in/91.5×91.5cm
Arts Council of Great Britain

70
Colour notations of wave lattice no.1 1973
Acrylic on cotton duck
36×36in/91.5×91.5cm

71
Colour notations of wave no.2 1973
Acrylic on cotton duck
36×36in/91.5×91.5cm

72
Colour notation of wave lattice no.3 1974
Acrylic on canvas
48×48in/122×122cm

73 *Illustrated in colur page 35*
Canterbury 1976
4 panels – acrylic on canvas
72×72in/183×183cm each

74
Mixed media construction 'Norway' 1976
Ink, crayon, wood, paper and elastic
23×26in/58×66cm

75
Stretched square wooden relief 1978
21×13in/53×33cm

76 *Illustrated in colour page 37*
Looped circle 1978
Paper, nails, wood, elastic, crayon and ink
31×27in/79×69cm

77
Stretched square 1979/83
Acrylic on board
22×56in/56×142cm

78 *Illustrated page 45*
Extended square 1978/82
Perspex, silk screen, oil, elastic and wood
24×80in/61×203cm
Arts Council of Great Britain

79
Mixed media construction 1980
Ink, crayon, wood, paper and elastic
51×31in/130×79cm

80
Elastic sculpture maquette 1980
Elastic, aluminium and wood
38×31×8in/97×97×20cm

81 *Illustrated page 56*
Relay drawing no.3 1980
Ink on paper
22½×52in/57×132cm

82
Stretched circle drawing no.1 1980
Ink on paper
22×30in/56×76cm

83
Stretched circle no.2 1980
Ink on paper
22×30in/56×76cm

84
Circle on sliced elastic 1980
Ink and coloured crayon on tracing paper
2 panels 71×27½in/180×70cm
1 panel 114×27½in/290×70cm

85 *Illustrated page 47*
Formation and transformation 1982
9 panels silk screened on paper and
laminated in plastic
each one is 24×24in/61×61cm square

86 *Illustrated page 40*
Requiem 1982/83
5 pieces
46×109in/117×277cm

87 *Illustrated page 41*
Systemic breakdown 1983
4 panels
Acrylic on paper
62×62in/157.5×157.5cm

88
Farnham relief 1983
Ink on stretched elastic and wood
23×57in/58×145cm

89 a/b
Round columns (a/b) 1984
Wooden discs and wire
Height 29in/74cm, diameter 7in/18cm

90
The worm 1975/84
Bronze Sculpture
Height 30in/76.2cm, diameter 4.5in/11cm

91
3 working drawings of round column 1984
120×33in/305×83cm

92
7 black columns 1984
Gouache on film
132×39in/3.3mtr×99cm

93
Requiem 1984
Acrylic on canvas
4 panels 48×48in/122×122cm each

94
Floorpiece 1984
Plywood, hardboard, paint and resin
120×120in/305×305cm

Graphic work

95/96/97 *Illustrated page 38*
Editioned photo etchings
Proofed 1976, Editioned 1982
Square in Circle 1
Square in Circle 2
Square in Circle 3

98/99/100/101
Proofed 1979, Editioned 1982
Concentric Circles *Illustrated page 38*
Circle in Triangle
Circle 1
Circle 2

102/103/104/105/106/107/108
Editioned silkscreens 1980/81
Pyramid 80
Axe Head 80
Looped Circle 80
Chessmen 67
Serial 67
Red China 1966
Multiple *Illustrated page 18*

109 *Illustrated page 39*
Nine stretches AP 1977

110 *Illustrated page 39*
Cross stretch (line) AP 1977

111 *Illustrated page 23*
Sussex 1967

Biographical Notes

Grafton Underwood 1946
Oil on paper 12 × 18in

Cork plant and bones 1953
Gouache on paper 22 × 30in

1917 Born at Kettering, Northamptonshire,
 11 September. Educated Bedales
 School.

1936–39 Cambridge University Hons degree in
 History and Anthropology.

1940–41 Ohio State University, studying
 Landscape Architecture.

1941–46 War Service in the Canadian Army.

1946 Began NDD course at Goldsmiths'
 College, but was dissatisfied with the
 teaching and gave this up.

1947–50 Schoolteacher at a prep school at
 Pitlochry in Scotland; holidays in the
 South of France and Northants painting
 on his own, mainly landscapes from
 nature.

1951 Married Marion Frederick.

1951–52 Worked as theatrical designer for
 repertory companies in Bromley and
 Barnstaple.

1953 Began full-time painting.

1953–55 Lived in Paris, attending Andre Lhote's
 Atelier intermittently for about six
 months.

1955–56 Lived outside Barnstaple in North
 Devon, painting and attempting to
 absorb the lessons of Cubism and
 pictorial space.

1956 Spent five or six months in St. Ives.
 Came to know Trevor Bell, Roger
 Hilton, Terry Frost, Patrick Heron, Peter
 Lanyon, Norbert Lynton, Bryan Wynter,
 Brian Wall and Karl Weschke.

1957 Moved to London. Met John Coplans
 and learnt from him to use silkscreens.
 Influenced by American Abstract
 Expressionism, particularly through the
 exhibitions at the Tate Gallery in 1956
 and 1959, and attempted to absorb the
 lessons first of Pollock, then de
 Kooning, then Rothko.

Seated Figure 1956
Oil on hardboard 40 × 30in

1957–62 Made after-image paintings, sculptures
 and reliefs, and attempted to float
 colour on or in front of the picture.

1959 Attended Harry Thubron's course at
 Leeds run on Bauhaus lines where he
 found confirmation for the objective
 rather than the subjective use of colour.

1959 First one-man exhibition at St. Hilda's
 College, Oxford.

1962 Attended the summer school at Barry in
 South Wales in order to use the tools
 and workshops to try to make his
 reflecting reliefs with metal instead of
 the aluminium foil he had been using.
 The course tutor, Tom Hudson, invited
 him to teach at Leicester Polytechnic.

1962 Birth of son, Simon Morton (Og) 15
 September.

1963–64 Part-time teacher at Leicester Polytechnic.

1963 Prizewinner at the John Moores' Exhibition, Liverpool.

1963–67 Made interference pattern, stripe and wave paintings, at first with the main emphasis on colour, then on shape.

1964–84 Regular part-time teaching at Bath Academy of Art, Corsham.

1965 Included in the 'Responsive Eye' exhibition at the Museum of Modern Art, New York. Awarded Second Prize at the John Moores' Exhibition, Liverpool, and a Gulbenkian Purchase Award.

1965–66 Organizing tutor of a course 'Optical Colour' at Barry Summer School, co-tutor Jeffrey Steele; met Anton Ehrenzweig.

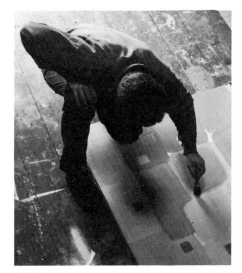

1958

Grabowski Gallery exhibition 1964

1967, 69 Course at Barry renamed 'Colour
70, 71 Kinetics'; co-tutors Jeffrey Steele, Richard Allen, Lily Greenham and David Saunders. Systems 'games' included tutors from other courses: Francis Shaw, Peter Maxwell-Davis both composers, Ann Sutton, weaver.

1966 Began to work in series.

1967 Artist-in-Residence, University of Sussex.

1968 Artist in Residence, American University, Washington DC. Experimented with staining techniques.

1969 Awarded Major Prize at Arts Council of Northern Ireland exhibition. Took part in 'Systeemi' exhibition of Systems Artists at the Amos Anderson Museum, Helsinki, Finland with Malcolm Hughes, Peter Lowe, David Saunders, Peter Sedgley, Jean Spencer, Jeffrey Steel, Michael Tyzack and Gillian Wise.

1970 Organized the exhibition 'Colour Extensions' for the Camden Arts Centre.

1971 First exhibition of the Systems group ('Matrix') at the Arnolfini Gallery, Bristol with several additional participants: Richard Allen, John Ernest, Colin Jones, James Moyes and Geoffrey Smedley.

1972–73 'Systems', an exhibition of the group at the Whitechapel Art Gallery afterwards toured by the Arts Council.

1973 'Systems II' at the Polytechnic of Central London, included his first works based on a grid of wavy lines.

1975 The Systems group broke up. With the help of Chris Briscoe at London University experimented with putting drawings onto a computer.

1976 Began to work with elastic cloth.

1978 Awarded Second Prize at the 4th Norwegian International Print Biennale.

1978–79 Worked on production of his book 'Elastic Membrane' with Jack Shireff.

1979 Awarded Edwin Abbey Memorial Scholarship.

1981–84 Part-time teacher at Chelsea School of Art.

1981 Exhibited at ON Gallery, Poznan, Poland. Met Ryzard Stanislavski. Gave seminar with K. G. Nilson at Konstfackskolan, Stockholm (and again in 1983).

1982 Member of exhibiting group 'Series' organized by Julian Robson.

1982 Death of son on March 10th.

1983 Panel member of the World Print Four conference held in conjunction with the 'World Print Four' exhibition.

Exhibitions

One Man Shows

1959 St. Hilda's College, Oxford.

1962 Grabowski Gallery, London, with William Tucker.

1964 Grabowski Gallery, London.

1967 Axiom Gallery, London.
University of Sussex, Brighton.
Arnolfini Gallery, Bristol, with Malcolm Hughes.
Betty Parsons Gallery, New York City, with Bruce Tippett, Michael Tyzack and John Walker.

1974 Lucy Milton Gallery, London.

1975 Jacomo-Santiveri Gallery, Paris, with Jeffrey Steele and Norman Dilworth.

1981 ON Gallery, Poznan, Poland.

1981 Kunstfackskolan, Stockholm, Sweden.

1981 Galleri Sankt Olof, Norrköping, Sweden with K. G. Nilson.

1983 Air Gallery, London

1983 Galleri Engstrom, Stockholm with Francis Pratt, David Saunders and Gillian Wise Ciobotaru. Toured to Norrköpings Konst Museum; Malmo Konsthall.

Group Exhibitions

1957 *New Exhibition 1957*, Penwith Society, St Ives.

1958 *AIA 25*, RBA Galleries,London; *New Vision*, Ferens Art Gallery, Kingston upon Hull.

1960 *AIA Group Show*, London; *Start a Collection*, AIA, London; *FPG 8*, Walker Gallery, London.

1961 *20 Painters*, AIA, London; *Momentum 2*, Raille Gallery, London.

1963 *Spring Exhibition 1963*, Bradford City Art Gallery; *John Moores' Liverpool Exhibition*, Walker Art Gallery.

1974

1964 *About Round/London Galleries*, Leeds University; *Seven '64*, McRoberts and Tunnard Gallery, London; *Painting towards Environment*, Arts Council of Great Britain touring exhibition; *Cross Section 1964: London-Leicester*, Leicester Museum and Art Gallery; *Formal Visual Dialogue*, University College of Wales, Aberystwyth; *New Painting 1961–1964*, Arts Council of Great Britain touring exhibition.

1965 *John Moores' Liverpool Exhibition*, Walker Art Gallery; *Spring Exhibition 1965*, Bradford City Art Gallery; *The Responsive Eye*, Museum of Modern Art, New York and tour in USA; *Trends*, Municipal Art Gallery, Manchester; *Post-Formal Painting*, Reading University; *Movements*, Municipal Art Gallery, Manchester.

1966 *Ten '66*, McRoberts and Tunnard Gallery, London; *First Exhibition*, Axiom Gallery, London; Arts Council of Northern Ireland; *Recent Purchases by the Contemporary Art Society*, Whitworth Art Gallery, Manchester; *Corsham Painters*, Arts Council of Great Britain touring exhibition; *Undefined Situation*, Howard Roberts Gallery, Cardiff; *Summer Exhibition*, Penwith Society, St Ives; *Kinetic Art*, Herbert Art Gallery, Coventry.

1967 *Recent British Paintings: Peter Stuyvesant Foundation Collection*, Tate Gallery, London; *Post-Formal Painting*, Midland Group Gallery, Nottingham; *1st Edinburgh Open 100*, Richard Demarco Gallery, Edinburgh; *John Moores' Liverpool Exhibition*, Walker Art Gallery.

1968 *100th Exhibition*, Grabowski Gallery, London; Henri Gallery, Washington D.C.; *Indian Triennale*, British Council.

1969 *Systeemi*, Amos Anderson Museum, Helsinki, Finland.

1970 *Open Painting Exhibition 1970*, Arts Council of Northern Ireland, Belfast; *Past Artists in Residence 1965–69*, Gardner Centre Gallery, Brighton; *Colour Extensions*, Camden Arts Centre, London.

1971 *Matrix*, Arnolfini Gallery, Bristol.

1972 *Systems Exhibition*, Whitechapel Art Gallery, London; *Third International Print Biennale*, Bradford; *System*, Lucy Milton Gallery, London.

1973 *First Contact*, Peterborough; *Systems II*, Polytechnic of Central London.

1974 *Critic's Choice* (Marina Vaizey), Arthur Tooth & Sons, London; *British Painting '74*, Hayward Gallery, London.

1975 *Contemporary Art Society Art Fair*, London; *Recent British Paintings*, Grenoble; *Chichester National Art Exhibition*, Old Olympia Electric Theatre.

1976 *Colour*, Southern Arts touring exhibition; *Rational Concepts*, touring museums in Holland.

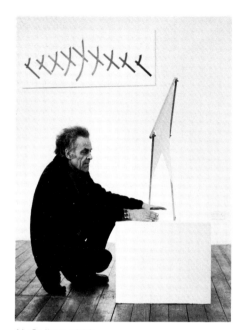

Air Gallery 1983

1977 Colour Symposium, Royal College of Art, London; British Painting 1952–1977, Royal Academy, London; Constructive Context, Arts Council touring exhibition; Rational Practice, Sussex University; Norwegian Print Biennale.

1979 Sixth International Print Biennale, Bradford; First European Print Biennale, Heidelberg; Eleventh International Print Biennale, Tokyo.

1979–80 Photography in Print Making, Victoria and Albert Museum, London.

1981 Book Works, touring exhibition in England and USA; Contemporary Artists in Camden, Camden Arts Centre, London.

1982 Painter-Printmakers, West Surrey College of Art and Design, Farnham.

1983–84 Series, Quay Arts Centre, Isle of Wight, touring exhibition.

1983–85 Concepts in Construction 1910–1980, exhibition touring museums in USA and Canada; World Print IV, Museum of Modern Art, San Francisco and tour of museums in USA.

1983 British Artists at Cyprus College of Art, Woodlands Art Gallery, London.

1984 British Artists' Books, Atlantis Gallery, London.

Public Collections

Tate Gallery; Arts Council of Great Britain; British Council; Walker Art Gallery, Liverpool; Contemporary Art Society; Huddersfield City Art Gallery; New College, Oxford; Sussex University; Manchester City Art Gallery; University of Wales; Gulbenkian Foundation; Stuyvesant Foundation; Victoria and Albert Museum; Museum of Modern Art, New York City; Museum Sztuki, Lodz, Poland; Poznan Museum, Poland; Amos Anderson Museum, Helsinki, Finland; Southampton City Art Gallery; Norrköpings Konstmuseum, Malmö Konsthall.

Bibliography

'Collectors' Choice' The Director, November 1960.
Norbert Lynton, 'Michael Kidner', Art International, November 1961.
David Sylvester, 'No Baconians', New Statesman, 20th April 1962.
Helen Lambert, 'Michael Kidner', New York Herald Tribune, 11th April 1962.
G. M. Butcher, 'Kidner and Tucker', Arts Review 7th April 1962.
Art Critic, 'Michael Kidner', The Times, 12th April 1962.
John Russell, 'Michael Kidner', Sunday Times, 8th April 1962.
Keith Sutton, 'Michael Kidner', The Listener, 12th April 1962.
Nigel Gosling, 'Michael Kidner', The Observer, 24th May 1964.
Art Critic, 'Michael Kidner', The Manchester Guardian, 6th January 1964.
Art Critic, 'Michael Kidner', Architects Journal, 14th October 1964.
Art Critic, 'Michael Kidner', Time Magazine, 24th October 1964.
Jules Goddard, 'Michael Kidner', Isis, June 1964.
Norbert Lynton, 'Michael Kidner', Art International, March 1964.
Robert Melville, 'Michael Kidner', The Sunday Times, 24th May 1964.
Norbet Lynton, 'Optical Art', New Statesman, 29th May 1964
Guy Brett, 'Michael Kidner', Manchester Guardian, 30th May 1964.
Norbert Lynton, 'Michael Kidner', Art International, June 1964.
David Thompson, 'Michael Kidner', Queen Magazine, 13th June 1964.
Art Correspondent, 'Michael Kidner' Architectural Review, October 1964.
M. Willet, 'Michael Kidner', Studio International, August 1964.
Eric Rowan, 'Michael Kidner', The Times, 21st January 1967.
Paul Overy, 'Michael Kidner', The Listener, 2nd February 1967.
Myfanwy Kitchen, 'Michael Kidner', The Guardian, 21st January 1967.
Bryn Richards, 'Kidner and Hughes Exhibition', Manchester Guardian, 31st October 1967.
Norbert Lynton, 'Systems and Sensibilities', The Guardian, 15th July 1967.
Art Critic, 'Michael Kidner', International Herald Tribune, 11th July 1967.
Art Critic, 'Michael Kidner', The Times, 28th July 1967.
Art Critic, 'Michael Kidner', The Times, 6th November 1967.
Constructivism, George Rickey, Studio Vista 1967.
Art Critic, 'Michael Kidner', The Evening Post, 30th October 1967.
Arts Magazine USA, November 1967.
Art Critic, 'Michael Kidner', The Guardian, 31st October 1967.

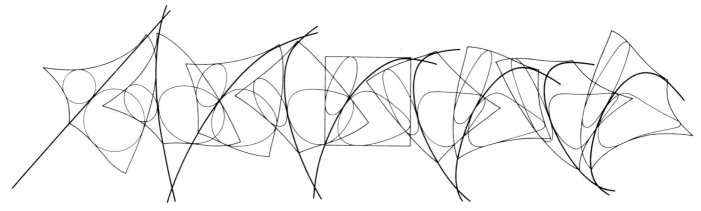

81 Relay drawing no.3 1980

Marjorie Bruce-Milne, 'Canvas and Sculpture Join Hands at the Tate Gallery', *Christian Science Monitor*, 12th December 1967.

John Russell, 'Pride of Bradford', *Sunday Times*, 28th March 1972.

Peter Fuller, 'Michael Kidner', *Arts Review*, April 1974.

Marina Vaizey, 'Signs of Life', *Sunday Times*, 29th September 1974.

Jean Spencer, 'Working Information', 1976 Limited Edition 250.

Terence Meascham, 'The Moderns', *Phaidon Press*, 1976.

Pat Gilmour, 'Michael Kidner', *Arts Review*, June 1979.

Walia, 'Contemporary British Artists with Photographs by Walia', 1979.

Arts Council Collection, 1979.

Pat Gilmour, 'Understanding Prints: a Contemporary Guide', 1979, *Waddington Publication*.

Pat Gilmour 'Elastic Membrane', *Arts Review,* July 1980.

Mel Gooding 'Michael Kidner/Julia Farrer'. *Arts Review,* 18th February 1983

Stephen Bann, 'Michael Kidner', *Art Monthly*, April 1983.

Peter Brades, 'Michael Kidner', *Artscribe*, April 1983.

Sarah Kent, *Time Out*, 14–18th February 1983.

Linda Talbot, 'Breeding Between the Lines', *Hampstead and Highgate Express*, 25th February 1983.

Catalogue Introductions:

Grabowski Gallery, Norbert Lynton, 1962

Painting Towards Environment, January 1964, Norbert Lynton

Formal Visual Dialogue, November 1964, Ronald Alley

Post Formal Painting, January 1967, Philip James

Four British Painters, Betty Parsons Gallery, October 1967

Gene Baro

Systems, 1973, Stephen Bann

Rational Practice, 1978, Stephen Bann

Publication

Elastic Membrane, published by Sovereign Press, USA and Circle Press, Great Britain.